Razzle Sonnets

MARK STANIFORTH

antisonnets.wordpress.com
fryuppublishing.wordpress.com

£1.20
Volume 7, Number 10
PUBLISHED BY
PAUL RAYMOND
Austria 70 Sch,
France 33 F. Fr.
Germany 150m
Italy 6900 lire.
Spain 565 Ptas
Publisher: Paul Raymond
Editor: Stephen Bleach
Assistant Editor: Jennie Crasswell
Art Director: Ian Midson
Art Editor: Cally Stewart

BEANZ MEANZ BUMZ!

FIGHT
ORGY
MANIA

GIRLS
ABOUT
TOWN

SEX VIDEO TITLES

PUNISHMENT
LINE

ULTIMATE CLIMAX

SWEDISH IMPORTS!

DIAL MY SEX SPOTS

BONDAGE SPECIAL

I
LOVE
A
CUCUMBER

THE ULTIMATE XXX

PANTIE PLEASURE

ANITA THE ESCORT

FRILLY KNICKERS

ABIGAIL
ADAM
Alice
AMANDA
AMY
Andrea
Andy
Angela
ANGIE
ANITA
Anne
ANNIE
ANTONIA
Barbie

Becky
BELINDA
Ben
Bernadette
BERNARD
Betty
Bill
Billy
Bobby
Brenda
Cally
Carl
Carla
Carmel

CAROL
CAROLINE
Carron
CATHY
Cheryl
CHLOE
Cynthia
Dan
DANIELLE
Danny
Darren
DAVINA
Dawn
DAWN

Debbie
DEBBY
DEBBYANNE
DEBEE
Denise
Dernella
Diana
DIANA
Diane
Dick
Donald
DONA
Doreen
Dorrin

Doug
Eileen
Ellen
Elvis
Emlyn
Emma
Emmanuelle
Erica
Ernie
Eve
FANNY
FELICITY
FI
FIONA

Fiona
FRAN
Frank
Frazer
Gareth
Gary
Gavin
Gaynor
George
Georgina
Giacoma
Ginger
GLENDA
Grace

Greta
Gwynne
Heather
HEATHER
HELEN
Henry
Hilary
Ian
Inga
Ingrid
INGRID
JACK
JACKIE
James

JAMIE
JANE
Jane
Janet
JANET
JENNA
Jennie
Jessica
JILL
Jill
JILLY
JIMMY
Jo
Jock

CREAM-CRAZY FIVE-

Jodie
Joe
JOHN
John
Josie
Judith
JULIE
Julie
June
KATE
Keith
KELLY
Ken
Kim

KIMBERLEY
Kylie
Larry
LEEANNE
Lesley
LESLEY
LINDA
LINDSEY
LINDY
LINZI
LISA
LIZZIE
LOLA
Lorna

Louise
LOUISE
LUCY
MADGE
Maggie
Mandy
MANDY
MARGARET
Margaret
Maria
Marisa
Mary
Masaha
Maya

Melissa
MICHELLE
Mick
Mike
MIKE
NATALIE
NICKY
NINA
Nina
PAM
PAMELA
Pat
PATRICK
Patrick

PAUL
Paul
Paula
Peggy
Pete
PETER
Peter
Petra
Piers
POLLY
Rachael
RACHAEL
Robert
Roderick

Ron
Sabrine
Sally
SALLY
Sam
Sandra
Sandy
Sarah
SASCHA
SCOTT
Severine
Shane
Sharon
Shaz

Shirley
Sidney
SOPHIE
Stephen
Steve
Sue
SUSAN
Susie
SUSIE
SUZETTE
SUZIE
Sybil
TANYA
Tanya

Tina
TINA
Tom
Tony
TRACIE
Tracy
TRACY
Ursula
Valerie
Vic
Vida
Vivienne
Wendy
William

tits
tits
tits
tits
tits
tits
tits
tits
tits
tits
tits
tits
tits
tits

cock
cock
cock
cock
cock
cock
cock
cock
cock
cock
cock
cock
cock
cock

clit
clit
clit
clit
clit
clit
clit
clit
clit
clit
clit
clit
clit
clit

dong
dong
dong
dong
dong
dong
dong
dong
dong
dong
dong
dong
dong
dong

cunt

cunt

cunt

cunt

cunt

cunt

cunt

cunt

cunt

cunt

cunt

cunt

cunt

cunt

muff
prick
fanny
pussy
knob
thatch
heath
dick
forest
slit
hole
box
tool
mound

bangers
cucumber
helmet
dirtbox
thunderbolt
melons
chopper
python
basketballs
truncheon
lolly
banana
hosepipe
lollipop

like an aromatic magnet
like a flexible dong
like a man
like a pimp
like a good, sharp spanking
like an uncooked hamburger
like a nice girl
like a challenge
like a hooker
like a golfing trolley
like an oven-ready chicken
like a flag pole
like a pistol
like a suicide

She just came up
She took one look
She put them on
She took them off
She says she just wants it
She turns around
She feels really
She's got it
She's one of those
She says
She thinks
She parts her legs
She reappears
She laughs
She wore navy blue

She leaves the wheels
She says
She goes
She hits the streets
She tells me
She just came up
She whips down her white
She takes on the most
She's taken off
She likes to leave
She wants
She needs
She wants when she wants it
She tells you what

0898 900 501
0898 900 556
0898 900 557
0898 900 558
0898 900 570
0898 900 585
0898 900 575
0898 900 590
0898 900 580
0898 900 565
0898 900 540
0898 900 545
0898 900 560
0898 900 595

0836 402 146
0836 402 147
0836 402 148
0836 402 149
0836 402 150
0836 402 151
0836 402 152
0836 402 153
0836 402 154
0836 402 155
0836 402 156
0836 402 157
0836 402 158
0836 402 159

0836 402 126
0836 402 127
0836 402 128
0836 402 129
0836 402 130
0836 402 131
0836 402 132
0836 402 133
0836 402 134
0836 402 135
0836 402 136
0836 402 137
0836 402 138
0836 402 139

Landlady
Window Cleaner
Gas Fitter
Milkman
Plumber
Police Officer
Farmer
Pimp
Sculptor
Au Pair
Sexologist
Manager
Fisherman
Butler

Maid
Hairdresser
Student
Investigator
Bicycle Courier
Baker
Waitress
Croupier
Cook
Gardener
Groom
Landlord
Housewife
Nurse

Lecturer
Masseuse
Fishmonger
Nanny
Photographer
Teacher
Air Hostess
Traffic Warden
Matron
Chiropodist
Park Attendant
Stripper
Painter
Pathologist

aching
aching
aching
begging
begging
bending
BONKING
BONKING
BONKING
BONKING
bursting
bursting
burying
buzzing

climbing
clutching
cock-teasing
coming
coming
COMING
coming
COMING
daring
deep-throating
delving
DEMANDING
DEMANDING
deserving

DIALLING
DIALLING
dressing
dripping
dripping
DRIPPING
driving
dunking
eating
EATING
eating
enjoying
exposing
exposing

feeling
feeling
feeling
feeling
feeling
feeling
feeling
feeling
feeling
feeling
feeling
feeling
feeling
feeling
FEELING

filling
finger-fucking
fingering
fishing
flagging
flashing
flashing
flicking
flirting
forcing
fucking
fucking
fucking
fucking

fumbling
gaping
gasping
gasping
gasping
gasping
gasping
GETTING
giving
giving
giving
giving
giving
giving

glistening
glistening
glistening
glowing
grabbing
gripping
gripping
GROANING
groping
having
having
having
having
having

holding
HUMPING
jumping
kissing
kissing
lasting
licking
LICKING
LICKING
LICKING
looking
LOOKING
looking
LOOKING

lovemaking
loving
LOVING
LOVING
making
making
massaging
masturbating
moaning
moaning
moving
moving
MUFF DIVING
muff diving

oozing
oozing
panting
panting
panting
PANTING
PANTING
peeking
peeping
PEEPING
penetrating
playing
pleasing
pleasing

poking
poking
poking
posing
pounding
pouting
pouting
pouting
pressing
pressing
probing
probing
probing
pulling

pulsating
pulsating
pulsating
pulsating
pulsating
pulsating
pulsating
pulsing
pumping
pushing
pushing
pushing
pushing
pushing

quivering
racing
racing
raging
raging
raging
relaxing
relaxing
RELAXING
revealing
RIDING
riding
riding
riding

rubbing
rubbing
rubbing
rubbing
rubbing
rubbing
rubbing
rubbing
screwing
screwing
screwing
screwing
screwing
screwing

SEEKING
SEEKING
SEEKING
SEEKING
SEEKING
shagging
shagging
shagging
shaving
sheep-shagging
shocking
SHOCKING
SHOCKING
SHOCKING

showing
showing
showing
sinking
sizzling
slapping
sliding
sliding
sliding
sliding
SNIFFING
soaking
soothing
sopping

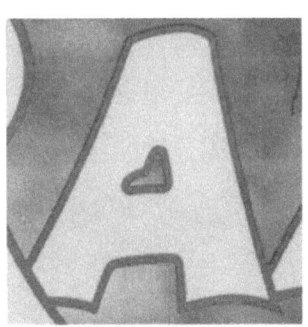

spanking
spanking
spanking
spanking
spanking
spanking
spanking
spanking
spanking
spanking
spanking
SPANKING
spanking
SPANKING

spurting
spurting
spying
squirming
squirming
STEAMING
stimulating
stimulating
stinging
stopping
stripping
stroking
stroking
stroking

stuffing
stuffing
stuffing
STUNNING
STUNNING
STUNNING
sucking
sucking
sucking
sucking
SUCKING
swallowing
swapping
swapping

taking
taking
taking
taking
TAKING
taming
tantalising
TANTALISING
teaching
teaching
TEASING
telling
telling
telling

TEMPTING
thrashing
throbbing
throbbing
throbbing
THROBBING
throbbing
throbbing
throbbing
thrusting
thrusting
thrusting
tickling
tingling

tossing
tossing
tossing
touching
touching
towelling
training
trickling
trying
twiddling
twisting
twitching
twitching
twitching

VIBRATING
VIBRATING
vibrating
vibrating
vibrating
vibrating
vibrating
vibrating
vibrating
VIBRATING
VIBRATING
vibrating
vibrating
vibrating

waiting
waiting
waiting
waiting
waiting
waiting
waiting
waiting
waiting
waiting
waiting
waiting
waiting
waiting

wanking
wanking
wanking
wanking
wanking
wanking
wanking
wanking
wanking
wanking
wanking
wanking
wanking
WANKING

wanting
wanting
wanting
WANTING
wanting
warming
warming
watching
watching
watching
watching
watching
watching
watching

wearing
wearing
wearing
wearing
wearing
wearing
wearing
wearing
wearing
WEARING
wearing
wearing
wearing
wearing

wetting
wetting
whipping
wife-swapping
wiggling
WILLING
WILLING
WILLING
WILLING
WILLING
wondering
wooing
working
writing

KONG-DONG

SUPER DONG

DOUBLE DONG

neediest
greediest
horniest
wildest
hottest
sexiest
sexiest
HOTTEST
wildest
WILDEST
hottest
SEXIEST
wildest
hottest

blonde
blonde
blonde
blonde
blonde
blonde
blonde
blonde
blonde
blonde
blonde
blonde
brunette
redhead
dark-haired

private massage
leisurely massage
corrective massage
sensuous massage
sensuous massage at Heathrow
St Albans massage
Brighton massage
massage in lady's own home
massage by attractive young lady
massage by beautiful blonde
massage by ex-glamour model (genuine)
massage by lovely busty brunette
massage, jacuzzi and herbal bath
luxury massage for the discerning businessman

COLCHESTER 74 Butt Rd.
COVENTRY 34 Walsgrave Rd.
CROYDON 109a Church St.
DARLINGTON 91 Victoria Rd.
DERBY 61 Osmaston Rd.
EXETER 133 Fore St.
FOLKESTONE 105 Dover Rd.
GLOUCESTER *78a Barton St.
GRIMSBY 189 Grimsby Rd.
GREAT YARMOUTH 3 Howard St. North
HEMEL HEMPSTEAD 193 London Rd.
KETTERING 25 Market St.
KINGS LYNN 41 Norfolk St.
KINGSTON 203 Kingston Rd.

WHO DARES BARES

blue movie
navy blue knickers
big blue helmet
BLUE CLIMAX
BLUE MOVIE
I'm blue for you
BLUE KNICKERS
used blue knickers
red raw
red hot
redness
red and throbbing
red leather
redhead

white thighs
white stilettos
white skirt
white flesh
white mini skirt
Snow White
white blouse
white overalls
white panties
white high heels
white man
WHITE LACY PANTIES
white stockings
TIGHT WHITE GUSSET

BLACKBURN
BLACKPOOL
BLACK MAMBA
black t-shirt
black undies
BLACK JACK
BLACK NYLONS
BLACK IS BIGGEST
BIG BLACK GUY
black stockings
black stocking tops
little black book
black suspenders
big black dildo

suburban

I'm Ginger Lynn
I'm not one to blow my own trumpet
I'm so hot and horny
I'm a great lover of women's stockinged feet
I'm more selective these days
I'm Fi, the fishmonger's wife
I'm an attractive 24-year-old
I'm sure she's lying
I'm quite well endowed
I'm getting so horny
I'm waiting for you
I'm tied up!
I'm waiting for you to use your whip
I'm wearing naughty undies

I'm randy Mandy
I'm looking for studs
I'm wearing it and I bet you want to hear about it
I'm tied up
I'm waiting for you to call
I'm young and very beautiful
I'm turned on!
I'm doing it all myself
I'm your wildest fantasy
I'm Sally, spank me
I'm so lonely
I'm a very fruity lady
I'm the mistress of all mistresses
I'm not the only one

I'M YOUR WILDEST FANTASY

naughtily
yearningly
gently
lovingly
casually
instinctively
passionately
discreetly
dangerously
slowly
tightly
quickly
dutifully
frantically

sadly
suddenly
vigorously
excitedly
accidentally
readily
instantly
easily
naturally
rapidly
meekly
liberally
simply
normally

severely
heavily
madly
uncontrollably
wildly
amazingly
perfectly
rhythmically
dimly
unashamedly
expertly
deliciously
discreetly
professionally

www.ingramcontent.com/pod-product-compliance
Lightning Source LLC
Chambersburg PA
CBHW030705220526
45463CB00005B/1916